Piet

Mondrian

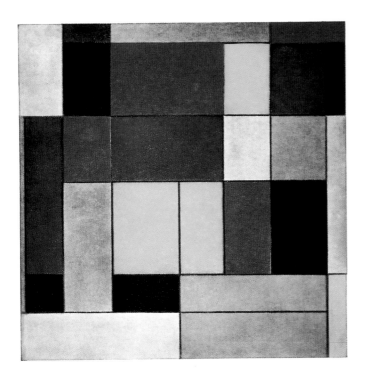

Published in 2004 by Grange Books
an imprint of Grange Books Plc
The Grange Kingsnorth Industrial Estate
Hoo, nr Rochester Kent ME3 9ND
www.Grangebooks.co.uk
ISBN 1-84013-656-1

Printed in China

Piet

Mondrian

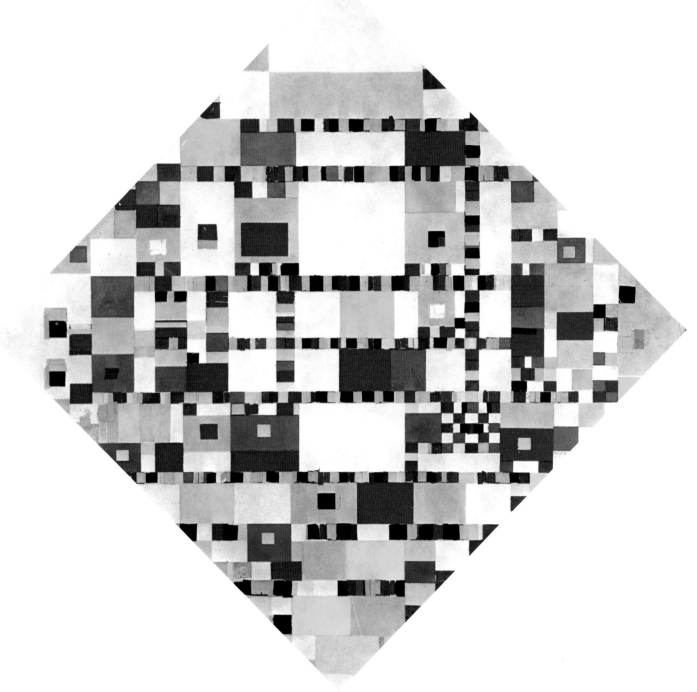

4

The Beginning: 1872-1925

By the centenary of his birth in Holland on March 7, 1872, Piet Mondrian had become a celebrated international figure. There were major exhibitions of his work in the United States and abroad, beginning with a retrospective at New York's Guggenheim Museum in the fall of 1971.

The artist's life and work were extolled in papers and articles published in more than 30 symposia, books, and periodicals. It is appropriate that most of these tributes originated in America, where Mondrian lived as a war refugee during the last four years of his life.

He had long held a dream of the United States as the land of the future and designed his paintings as harbingers of a "new world image."
The image changed in America yet the theory remained basically as formed in Europe. It was rooted in Holland, as were many aspects of the artist's personality and artistic philosophy.

His father attained diplomas in drawing, French, and headmastership in The Hague and taught there for several years before being appointed headmaster of a school in Amersfoort. During the ten years that he and his wife Christina Kok lived there, they had the first four of their five children. They named their second child and eldest son (according to the Dutch spelling) Pieter Cornelis Mondriaan, Jr.

Uncle Frits Mondriaan often visited his brother's family when he worked in the vicinity of Winterswijk. There, and later in Amsterdam, he took his nephew on sketching expeditions into the surrounding countryside. Piet acquired technical skill from his uncle, if not his sense of composition. Any comparison of canvases by the two makes clear that the younger artist's understanding of spatial relationships far exceeded that of the elder.

1. *Victory Boogie-Woogie*, 1943-44. Oil on canvas with colour ribbon paper. Gemeentemuseum, The Hague

A family friend paid for young Piet's studies at the Amsterdam Academy of Fine Art, which he attended from the ages of 19 to 22.
While he continued to paint landscapes, and occasionally to sell them, Piet's artistic interests gradually turned away from those of his father and uncle.

He became less and less a realist and, while he continued to use the same painterly strokes as before, the young Mondrian began to heighten his color, influenced by Impressionist and Post-Impressionist works brought back by friends from Paris.
The artist explained his transitional work of this time by saying that he had "increasingly allowed color and line to speak for themselves" in order to create beauty "more forcefully . . . without verisimilitude."

2. Last photograph of Mondrian in New York, 1944, taken by Fritz Glarner

Through consistent abstraction, he realized that the straight line had greater tension than the curved line and could therefore express a concept like vastness better than a natural line.

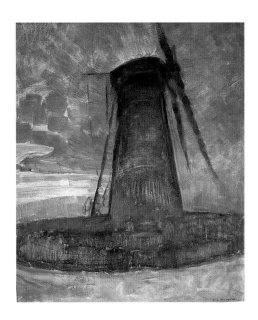

He had been so inspired by the French Cubist paintings exhibited in the fall of 1911 in Amsterdam that he left for Paris the following spring in order to confront their sources more directly.

The artist was thoroughly committed to Picasso's and Braque's theory of Cubism. Mondrian worked to suppress the solids and voids of natural subjects in favor of their flat, geometric equivalents.

The elements were no longer identifiable as belonging in nature yet were still vaguely natural in form and color. This equivocation brought him to a turning-point: "Gradually I became aware that Cubism did not accept the logical consequences of its own discoveries; it was not developing abstraction toward its ultimate goal, the expression of pure reality. . . . "

Mondrian lived in Paris for two years before he was called home in 1914 by the illness of his father.

3. *The Mill at Domburg*, 1909

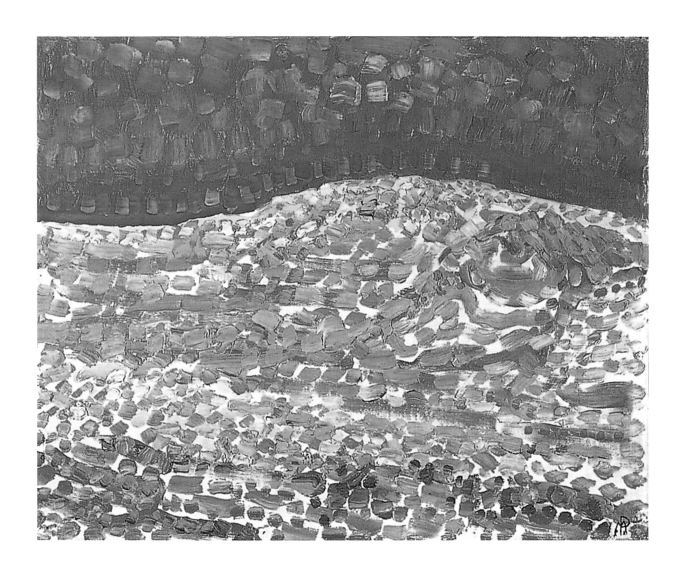

4. *Dune II*, 1909.

Gemeentemuseum,

The Hague

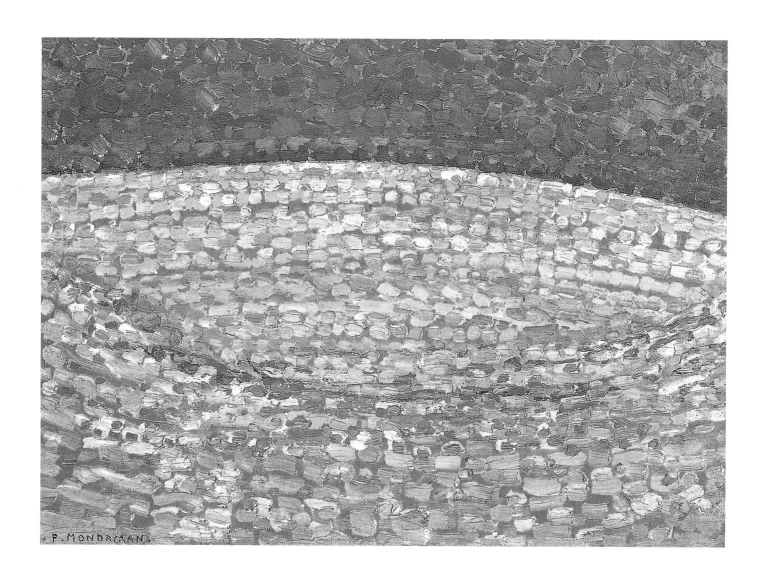

5. *Dune*, c.1910

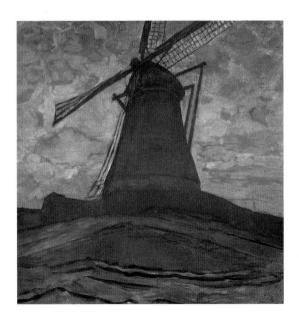

He expected to stay in Holland only a fortnight, but World War I erupted while he was there and the Dutch borders were closed. This forced him to remain for five years.

What seemed at first a depressing turn of events, however, became a fortunate hiatus. During the years 1914 to 1919 he met several other painters, sculptors, designers, architects, and writers who were either native to the country or found themselves in it because of the war.

Of greatest importance to the artist's development was Theo van Doesburg, who proposed that artists who were willing to sacrifice their "ambitious individuality" should form a "spiritual community" around a periodical published under the name *De Stijl* ['Style'].

6. ***The Mill***, 1907-08. Stedelijk Museum, Amsterdam

The artists whom van Doesburg drew into his plan came from what he called "the various branches of plastic arts." They pledged to search for the logical principles in each of their art forms that would meld with those of their colleagues to form a "universal language" of art, or "style."

7. ***Windmill in the Sunlight***, c.1911

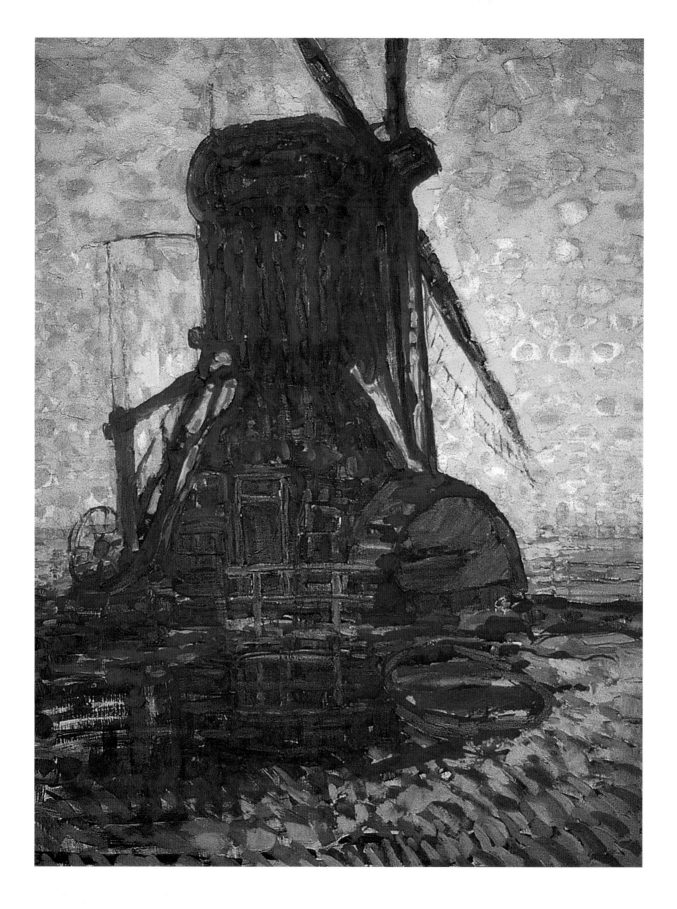

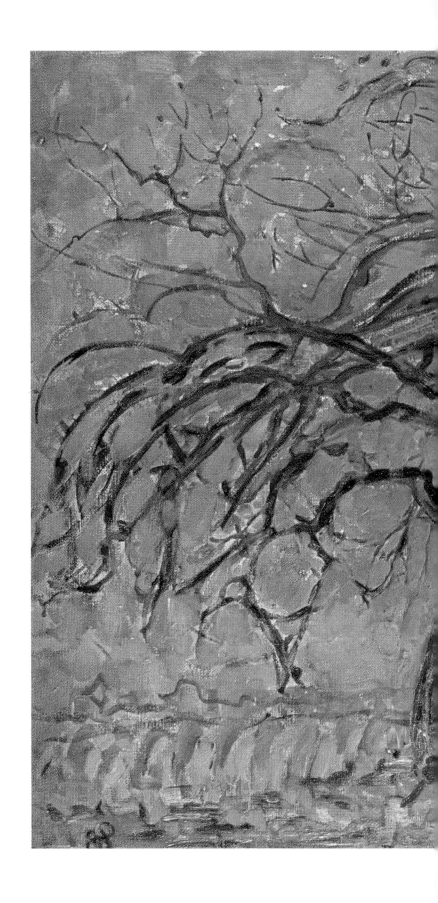

8. *The Red Tree*, 1908.
 Gemeentemuseum,
 The Hague

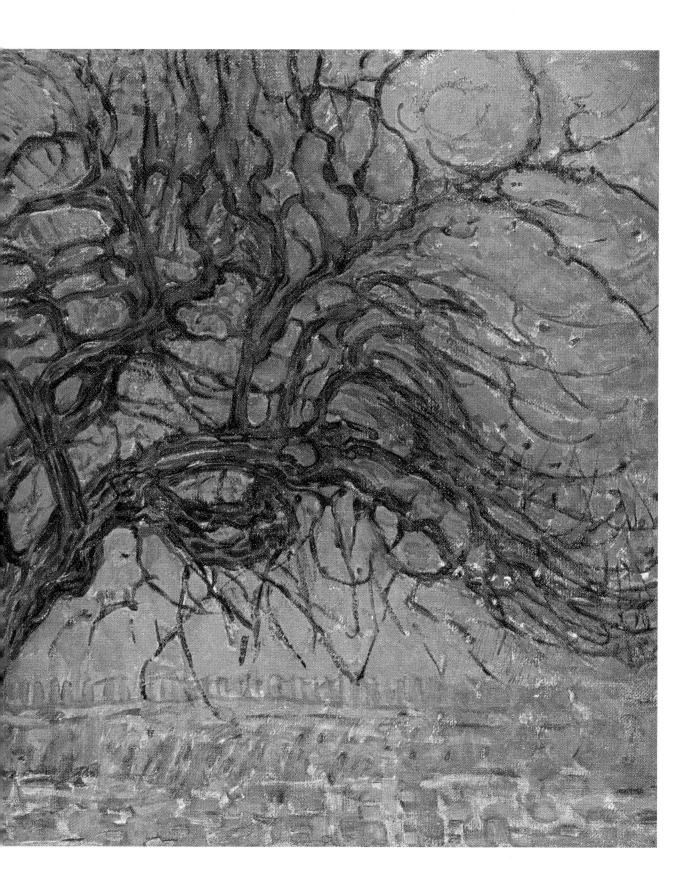

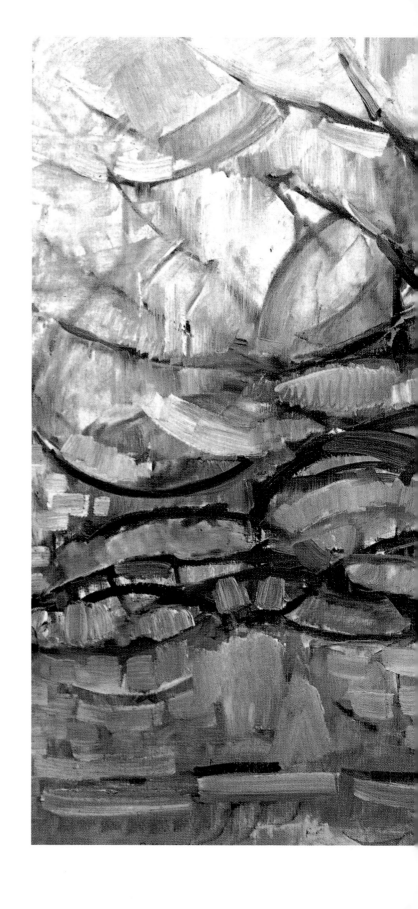

9. *The Grey Tree*, 1911

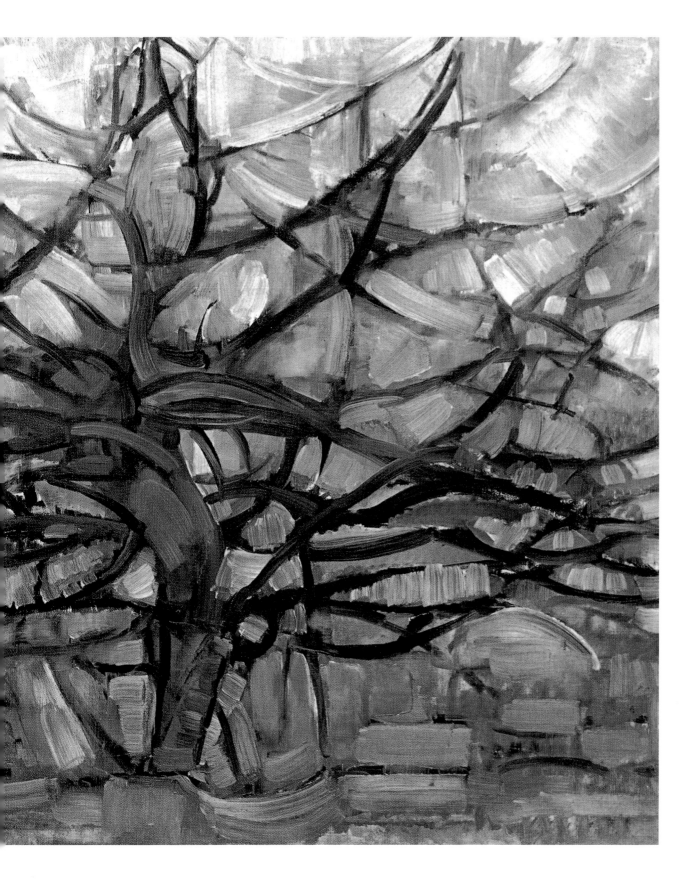

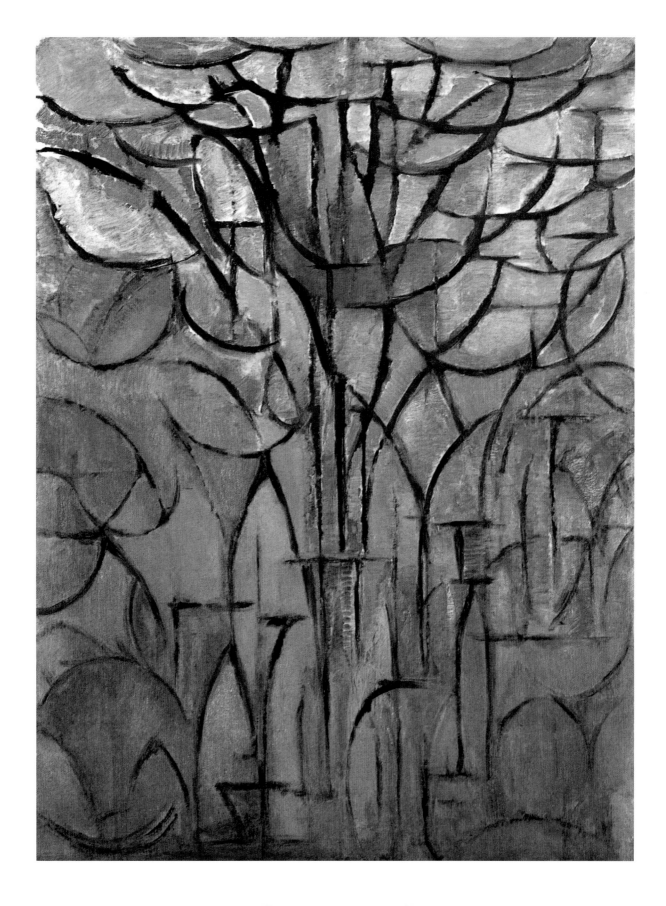

The result would be both an artistic style and an aesthetic lifestyle. By 1917, when he began to write essays for van Doesburg's publication, the artist had established his theory intellectually.

In paintings of 1916 and 1917, such as an unfinished *Composition in Line* and the *Composition in Color A* and *Composition in Color B*, Mondrian first succeeded in separating line and color, as elements, from the motifs of a church façade and the sea and pier of Domburg.

The last paintings he completed in Holland and those done after he returned to Paris in 1919, through the first two or three years of the 1920s, represent successive attempts to define the new image visually.

Mondrian carried the paintings through various stages in which, at first, he turned the elements into uniform planes colored in muted versions of the primaries.

He separated the planes so that they seemed to float against a white background, but concluding that this effect was still too "natural," he then connected the planes in a regular grid covering either a rectangular or a diamond format.

While the planes were still connected, in the next phase the artist made them larger and unequal in size and colored them in primaries or in values of black, white and gray.

He attenuated the black planes to make them extend alongside the colored and non-colored planes.

The blacks then served as structural bars holding the other planes together while at the same time making them more discrete. Like the canvas, the smaller rectangles or planes represented both form and space.

10. *The Tree*, 1912.
 Carnegie Institute,
 Museum of Art,
 Pittsburg

The colors of these planes stood for the intensities and values of nature, cleansed and rendered to their primal color states - red, yellow, and blue - and primal noncolor states - black, white, and gray.

Black planes performed multiple roles. In addition to their noncolor function, they were structural, determinate, and active. By creating paths of movement for the eye, black planes also added a sense of energy.

Although the parts were important, the artist wanted always to emphasize their subordination to the harmony of the whole. Different in size and color, they had equal value, or equivalence because of their similar nature.

Even when smaller areas of color were balanced against larger areas of noncolor, they had the feel of equal weight, or equilibrium when the proportions were right. *Composition*, 1921, exemplifies the artist's principles at work.

So there could be no confusion with the usual implication of space receding behind the frame, Mondrian had mounted the canvas on the frame, thereby projecting the painting's actual space into the room.

Working, therefore, in the "manner of art," Mondrian had created a "new structure" that in contrast to life was "exact": the fact that it was "real" did not mean that the painting was a material thing only - actually, the artist associated the reality of the work with a super-reality or universal ideal.

Here was the artist's ultimate duality - an object seemingly devoid of life, yet conceived as life itself - not in the sense of a deficient or incomplete fragment but a finite particle that contains within its structure the promise of its infinitude.

11. *Nude*, c.1912

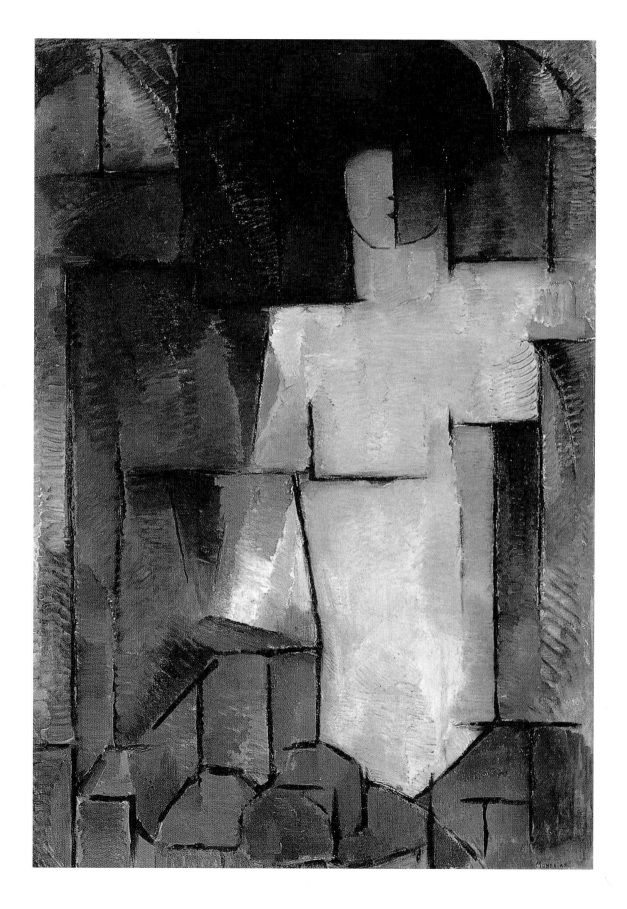

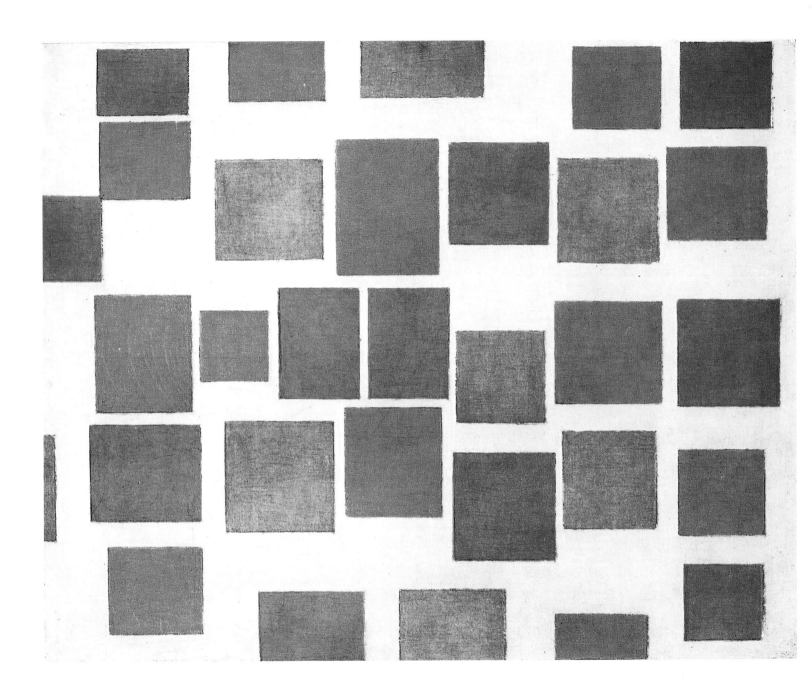

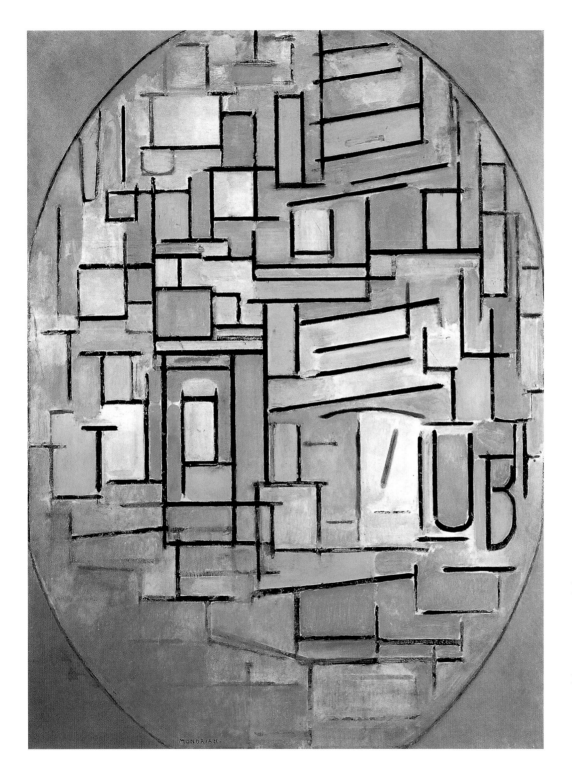

12. ***Composition n°3 with Color Planes***, 1917

13. ***Oval Composition***, 1914. Gemeentemuseum, The Hague

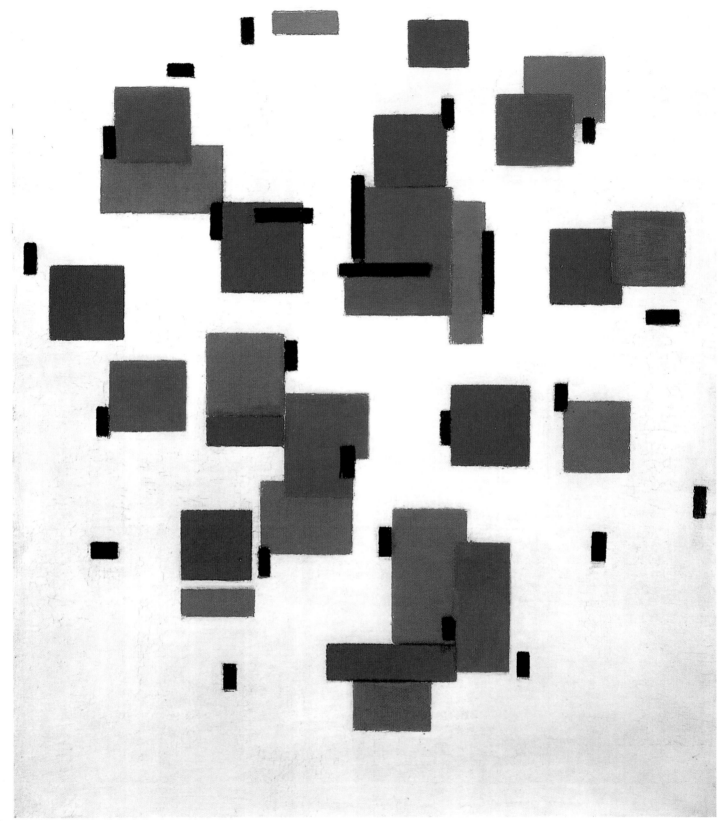

By creating this particle of life, Mondrian had not illustrated pure reality or pure beauty. He had made the painting be that reality. He had thus presented art in its most vital form, and life in its most unified form. As Mondrian stated, succinctly: "Unity, in its deepest essence, radiates: it is Life and art must therefore be radiation."

The Years Between 1925-1940

Since returning to France from Holland in 1919, the artist had been at work on a series of "Neo-Plastic" canvases.

Once he had begun to achieve the visual counterpart for his "new reality," its variations within the rules seemed endless. Mondrian proved that he could maintain the canvas's integrity with fewer elements.

At least once, in *Composition with Yellow Planes*, 1933, the artist reduced the elements to four linear planes of a single color, obviously yellow.

This was a square canvas turned diagonally. He had first done these "lozenge" or "diamond" paintings in 1918 and 1919 in order to create tension between the external format and the internal elements.

The Neoplastic paintings were generally too stringent for the French. Mondrian was never invited to have a one-artist exhibition nor was any of his works acquired for a French collection until years after his death.

Even though Paris was the international center of art, the French did not take to pure abstraction.

This indifference was the reason abstract artists turned to one another for support and organized groups like Cercle et Carré, in the late 1920s, followed by Abstraction-Création, in the early 1930s.

14. *Composition on White Ground A*, 1917. Kröller-Müller Museum, Otterlo

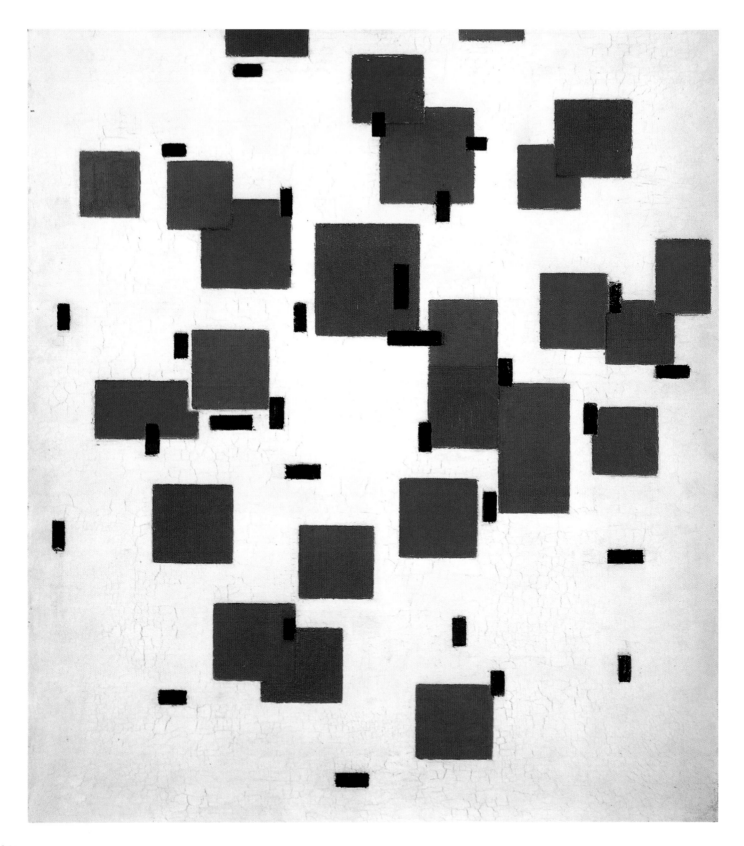

Mondrian was already a member of the older generation when he returned to Paris, and for this reason he remained outside the circle of younger artists.

Nevertheless, his reputation grew among them, and occasionally they visited him in his studio. Mondrian did not share himself easily with others, but neither did he live entirely as a recluse.

From 1921 until 1936 the artist lived in a building on the Rue du Départ, a street that ran parallel to the east side of Gare Montparnasse.

Undoubtedly, the spareness of this studio (and others to follow) was dictated by economy, the whiteness by need for light and cleanliness in accordance with the artist's innate "Dutchness," but there were other factors at work.

Mondrian himself expressed his conviction that a "present-day artist should show preference for the trend of his age in all matters," even his studio: "everything should contribute to the harmony."

Several visitors had vivid recollections of their first encounters with Mondrian's Rue du Départ studio and with the artist himself.

His relationship with Theo van Doesburg began in Holland during World War I. During the period from the mid-late 1920s, Theo and his second wife, Nelly, were often with the artist.

According to Nelly, Mondrian was a far more assertive individual, personally, than usually pictured to be: he could be cool, even cutting. She thought the fact that he never married "came as close as anything could to constituting a personal tragedy."

He left Paris for London on September 21, 1938, because war was already threatening France.

15. *Composition on White Ground B*, 1917. Kröller-Müller Museum, Otterlo

It was a wrench for the artist to leave his adopted city. Mondrian took a room on the first floor of a drab three-and-a-half story building, next to the intersection on Parkhill Road.

Among the artists who lived in the neighborhood were Naum Gabo, Marcel Breuer, Walter Gropius, Herbert Read, Roland Penrose, Paul Nash, Adrian Stokes, John Summerson, Cecil Stephenson, and their families.

The presence of Gropius, Gabo, and Mondrian, above all, undoubtedly focused and energized the native effort. Most of the other artists treated him with reverence mingled with protectiveness and even a little pity - attitudes that were somewhat patronizing.

When Mondrian began to paint in London, he confined himself primarily to works already begun in Paris.

His British paintings are rarely noted as such, but Lawrence Alloway, who saw them hanging in the Whitechapel Gallery exhibition of 1955, characterized those done after 1937 as having a "mounting intricacy" due to the multiplication of lines and shrinking color areas.

The artist had a few collectors in London, but most of them preferred the calmer Paris paintings to the more complex London ones.

Despite the fact that Mondrian continued to paint in London, he would later write back to a friend that work was too difficult for him there. The artist evidently stopped painting altogether in June, 1940.

Mondrian's desire to go to America went back a long way, probably as far as Paris in the mid-1920s when he first began to sell his works to Americans. The first American collector to visit the artist was Katherine Dreier, who came in 1926.

16. *Self-portrait,* 1918

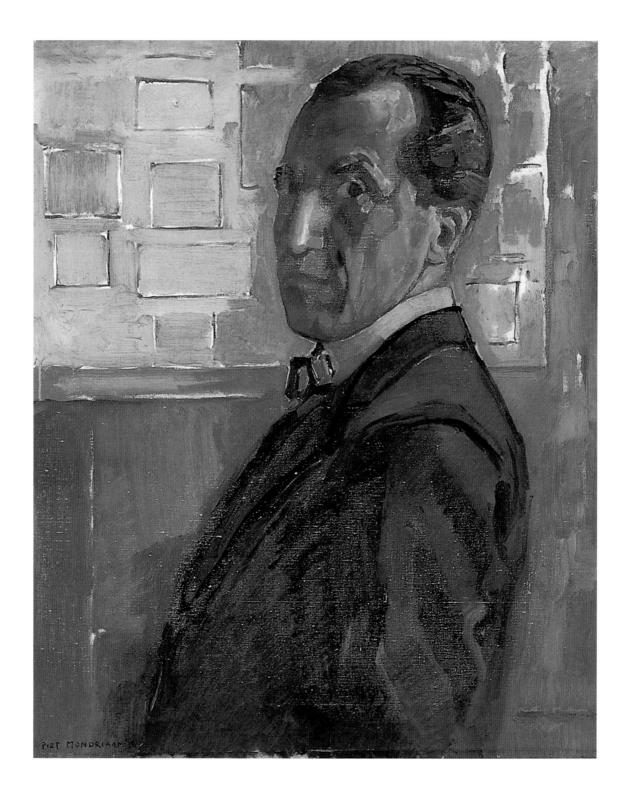

Together with Duchamp and Man Ray in 1920, Dreier had founded the Société Anonyme in New York as an "International Organization for the promotion of the study in America of the Progressive in Art."

Under the auspices of the Société Anonyme, Dreier inaugurated the first major exhibition of modern art in America since the Armory Show.

It was held at the Brooklyn Museum in 1926. Dreier visited Mondrian's studio and acquired one of his diamond compositions, *Painting I*, 1926, for the exhibition.

Her statement by the artist's entry in her catalogue undoubtedly seemed overblown at the time: "Holland has produced three great painters who, though a logical expression of their own country, rose above it through the vigor of their personality - the first was Rembrandt, the second was Van Gogh, and the third is Mondrian."

Dreier's exhibition was more productive than she could possibly have foreseen, for she introduced many artists to America, including Mondrian, and the exhibition was visited by young Americans who long afterwards remembered its influence on them.

Numerous exiled artists were already in the United States including Ozenfant, Chagall, Tanguy, Dalí, Berman, Tchelitchew, Seligman, Hofmann, and Grosz.

Mondrian would come in October and Léger in December of 1940. Max Ernst and André Masson would arrive in 1941, not to mention Breton, Lipchitz, Matta, and Zadkine.

And by that time, or later, Miró, Gabo, and Feininger had arrived. Neither the incoming artists nor those who received them could have imagined the reciprocal influences they would exert on one another.

17. *Checkerboard, Bright Colors*, 1919

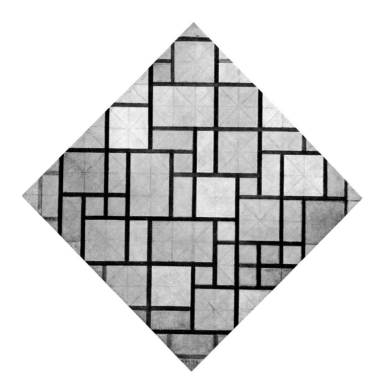

This was particularly true of Mondrian, who would be cited first for his influence on architecture and design.

The seeds were already laid, however, for the more lasting effect he would have on "fine" art. Although isolated from the mainstream and without any cohesion among themselves, a small number of American artists had turned to abstract styles in the 1920s and 1930s, but they had few, if any, places to exhibit.

Nevertheless, they felt rebuffed when their works were excluded from exhibitions of 1935 and 1936 held at the Whitney Museum and the Museum of Modern Art, even though their paintings would not have fit into the curatorial contexts of either.

18. ***Still Life with Ginger Pot***, 1911-12. Gemeentemuseum, The Hague

19. ***Composition, Bright Color Planes with Grey Lines***, 1919. Kröller-Müller Museum, Otterlo

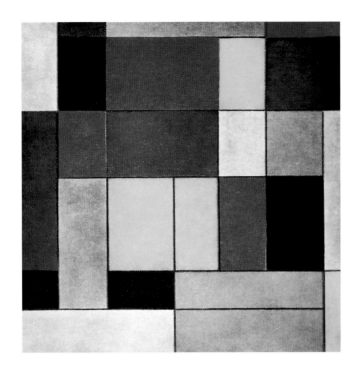

Consequently, these artists founded the American Abstract Artists (AAA). Without public interest, the members had to support their own showings by prorating all expenditures.

In order to increase public understanding as well as provide themselves with a forum, they edited a booklet with essays by several artists. The members evidently sent their publication to Mondrian in Paris because he replied with a congratulatory note, written on March 22, 1938, saying it was "une grande joie" to see their activity, and wishing them "la force nécessaire à continuer."

20. ***Composition with Grey, Red, Yellow and Blue***, 1920. Tate Gallery, London

21. ***Painting II***, 1921-25. Max Bill Collection, Zurich

At the AAA meeting of November, 1940, they moved to invite Léger and Mondrian, who were already in New York, to join them as regular members. Mondrian replied in English on January 3, 1941.

His note to secretary Holtzman said that he appreciated the "welcome" and would be pleased to join the group and send his work to the next exhibition.

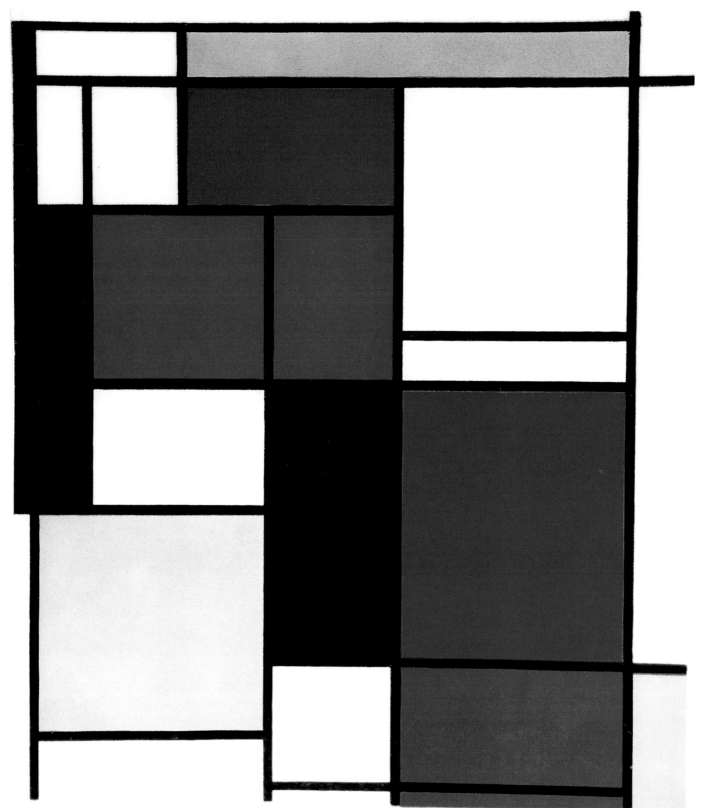

33

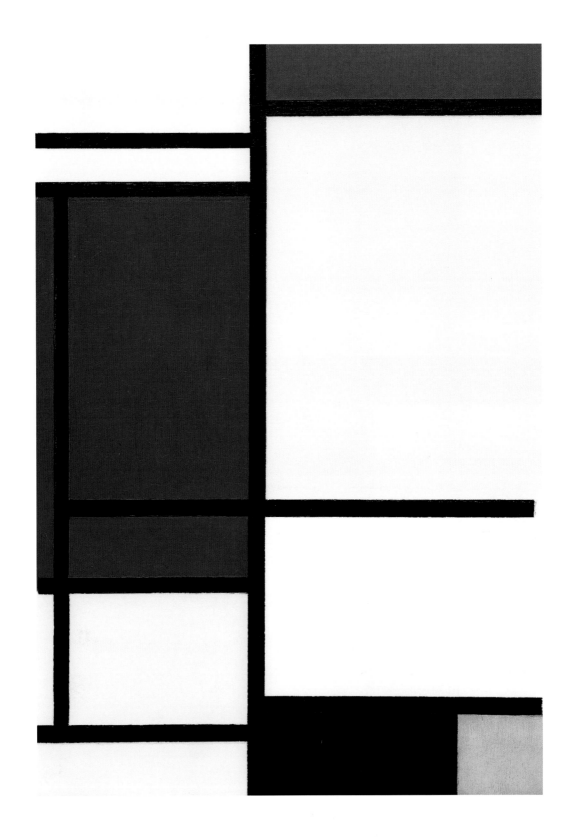

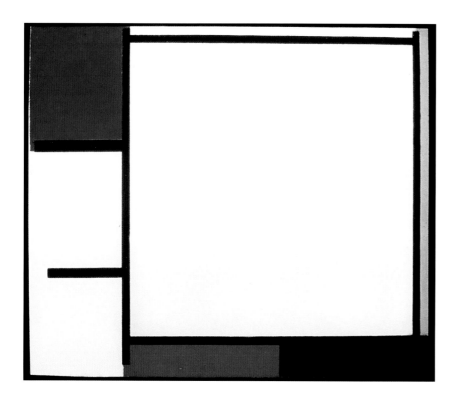

Mondrian had arrived in New York exactly three months before, after enduring several weeks of the terrible bombing attack on London that began in August, 1940. After the bombing started, Holtzman wrote that it was time for the artist to come to America.

As he told the story: "My lawyer in New York wangled a flight from Lisbon, but Mondrian wouldn't fly - came by convoy. He kept his life-vest on, never had his clothes off. The trip took a whole month. I took him off the ship, and he was exhausted. (...) That night, I picked him up and brought him to my house for dinner. I'll never forget. He was long an admirer of real jazz, but had never heard of Boogie-Woogie, which was fairly new. I had a fine hi-fi set and discs that had just appeared. He sat in complete absorption to the music, saying, 'Enormous! Enormous!'"

22. *Composition I*, 1921. Gemeentemuseum, The Hague

23. *Composition with Red, Yellow and Blue*, 1922. Stedelijk Museum, Amsterdam

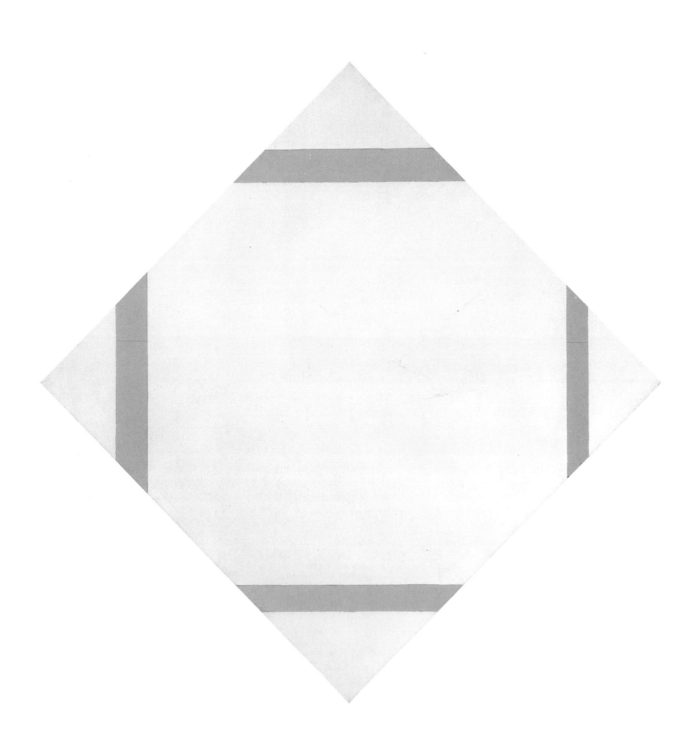

The Metropolis: 1940-1944

The artist had arrived in New York on October 3, 1940. He was 68 years old. It took some time for him to adjust his dream of America to its everyday reality.

For the first few weeks after his difficult crossing, he was weak and dispirited. As his health and energy returned, Mondrian began to make his way around the city with the help of newfound friends. The artist also began to renew acquaintances made in Europe.

Through Abstraction-Création in Paris he had known Carl Holty, who was now in America. The American Abstract Artists members felt themselves very close to the elder artist.

At the AAA meeting of January 24, 1941, they announced his and Léger's acceptance of membership. Mondrian had the most profound effect on the abstract artists.

Many of the artists admired his humane qualities, as exhibited by paying the modest dues of their organization (a mere $4 per year, but the gesture was meaningful, especially since Léger did not do so) and seen in the fact that, as Holty said, "Mondrian was the only refugee who did not act as if he were slumming; he was wiser, not precious - of a more truly generous nature."

Unaware of their significance, Holty and AAA members had witnessed changes that would characterize the artist's New York period from then on. Mondrian had already found that the multiple lines he added to his paintings in England gave them a sense of life and implied movement.

This was because the viewer's eyes followed the directions of the lines and responded to the "optical flicker" that seemed to appear at their crossings.

24. *Composition with Yellow Lines*, 1933. Gemeentemuseum, The Hague

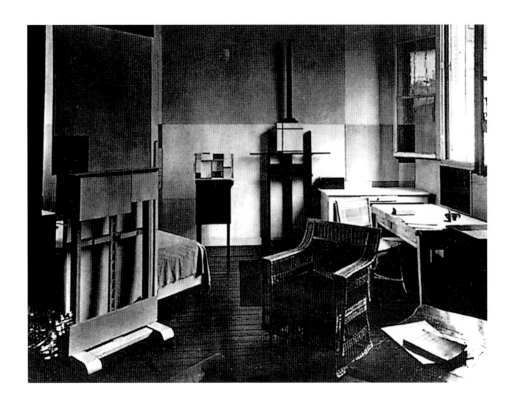

In London, Mondrian apparently added black lines to paintings begun in Paris and then continued to add them to the same paintings in New York.

Composition in Red, Yellow and Blue, 1939-1942, is an example of a painting on which the artist worked in all three cities. The additions of color planes, for the first time unbounded by black, that connected the lines to one another and to the frames had to do with the clearer light of New York.

Inevitably, the artist began to question any use of black as unnecessary and undesirable. Mondrian had admired Holty's color when he visited that artist's studio in the Master Institute.

More of a theorist than Holty, he was impressed with the brilliance that the younger man achieved as a natural colorist and finally decided on adding more color to his own surfaces.

25. Mondrian's Rue du Départ studio

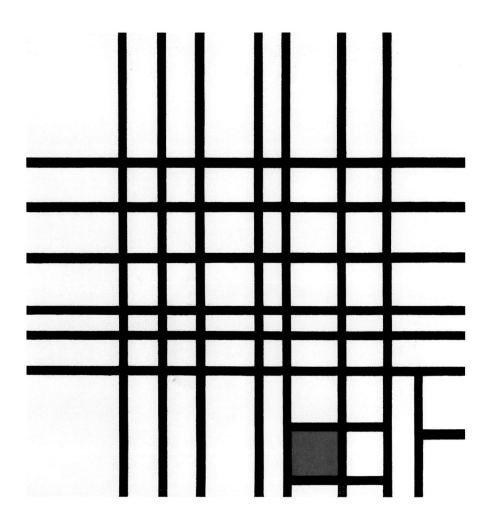

The additional color would, he thought, mitigate the insistence of multiple black lines and at the same time retain and even increase their vitality.

"Once Mondrian got into the shifting colors, however, black disturbed the equilibrium, so he decided to leave it out entirely," said Holty. It would have been technically impossible to make a complete change to color, had not Holty and other friends told the artist about Dennison Scotch Tape, which was processed in primary colors.

Painting had been a painfully slow process for Mondrian in Europe. Even changing a black line had required that he use paint remover and then build up the surface again.

26. *Composition II with Blue Square.*
1936-42.
Oil on canvas.
National Gallery of Canada, Ottawa

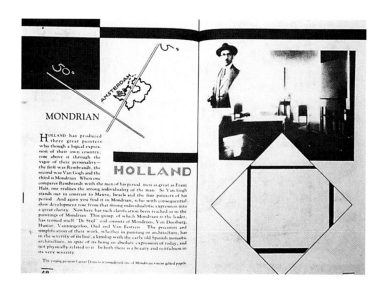

Although the final process of painting below where the tapes had been placed was just as painstaking, now he could plan the picture's composition much more easily, as he began to do with the "New York City" paintings. Moving the tapes back and forth allowed him to work "more than ever by intuition and the eye, not by mathematics or formula."

That there was public awareness of the importance of the refugees was demonstrated in December 1941, when the broadly circulated magazine *Fortune* featured twelve of the artists, including reproductions of their works and a section devoted to their influences, already perceivable in commercial art.

Composition in Black, White, and Red, 1936, was reproduced on the first page of the follow-up article on the artists. Beneath the painting, Mondrian was called "an architect's artist" who had an important effect upon typography, layout, architecture, and industrial design.

His influence was said to be ubiquitous, "in books, magazines, posters, trademarks, linoleum, offices - even the tabletops at Childs."

27. *Painting I*, 1926.
 Museum of Modern
 Art, New York

28. Mondrian entry
 pages in Katherine
 Dreier's catalog for the
 Brooklyn Exhibition,
 New York, 1926

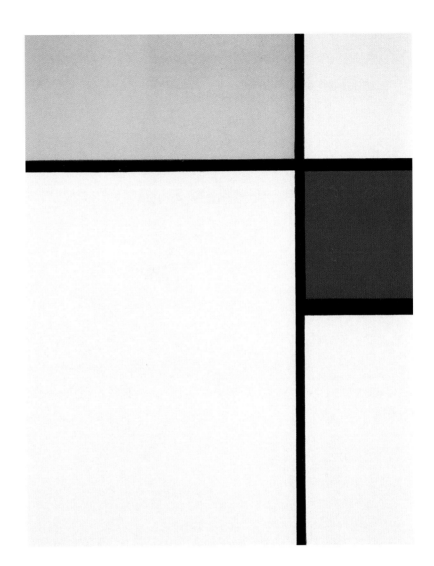

29. ***Composition with Blue and Yellow***. Gallatin Collection, Philadelphia Museum of Art

30. ***Opposition of Lines: Red and Yellow***, 1937. Gallatin Collection, Philadelphia Museum of Art

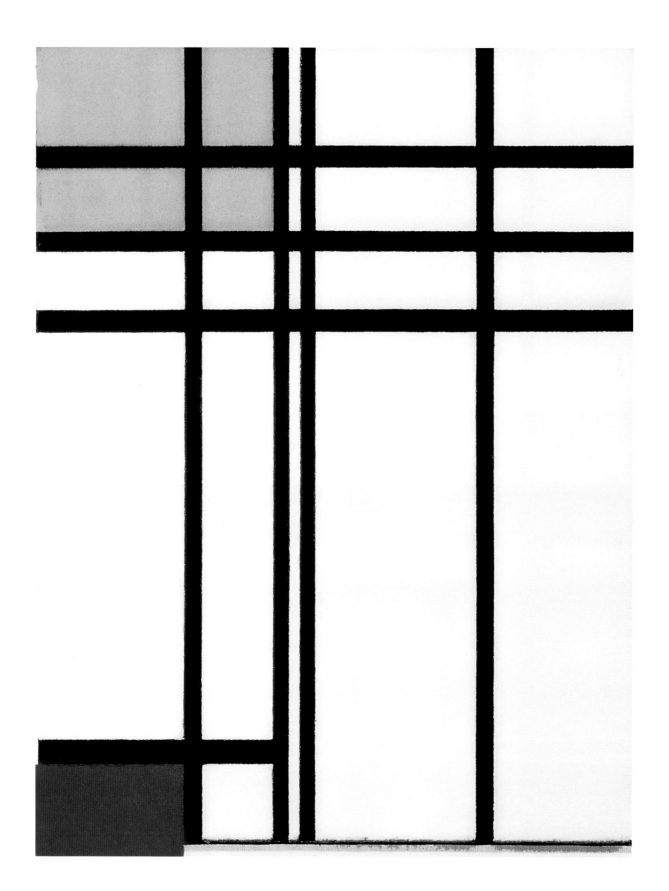

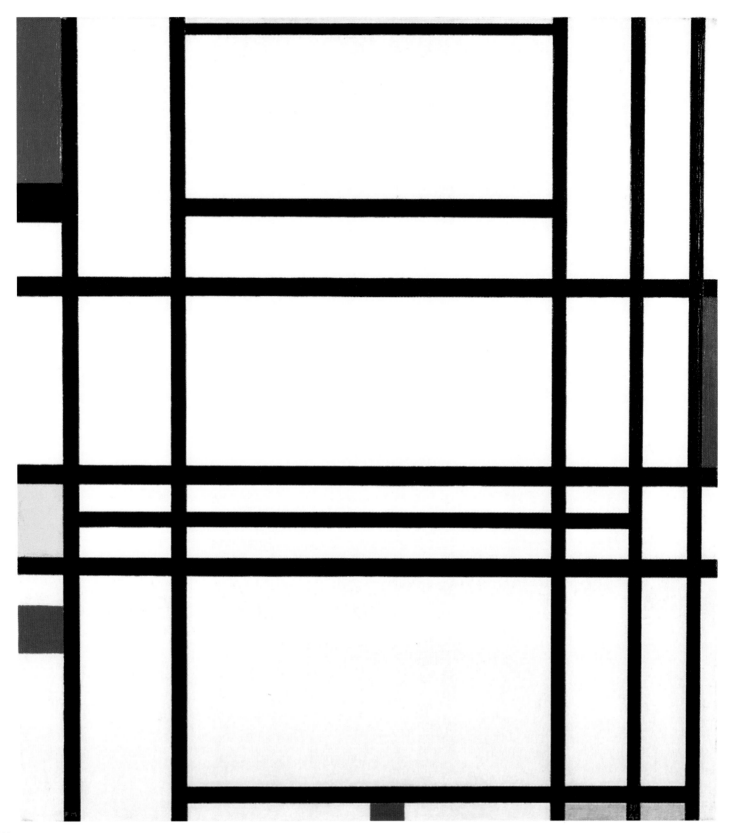

The entire section concluded with a page designed to resemble one of Mondrian's distinctive compositions.

Perhaps the most gratifying event of the artist's first years in New York took place in January, 1942, when the only one-man show of his life was held at Valentine Dudensing's Gallery.

In the few reviews of the exhibition, the painting called *Boogie-Woogie* received the only specifically sympathetic notice. Evidently, Mondrian disappointed many guests who had come just to meet him, because he had heard that artists did not appear at their own openings.

Mondrian had been "the whipping-boy of the Surrealists in the 'dog-eat-dog' atmosphere of Paris," according to Holtzman. Artists who came to New York (including Breton) met Mondrian and liked him but, as Janis said, they paid no attention to his art.

After a few years, they changed their minds, though, calling him one of themselves, because he was "so obsessed with his image."

The artist told an interviewer that he felt "closer to the Surrealists in spirit, except for the literary art, than to any other modern painters." Mondrian tempered his reactions toward contemporaries, sometimes negatively. He said to Holty that Picasso was "too pictorial."

Toward young artists, however, he was kinder. Jimmy Ernst overheard Mondrian refer to Jackson Pollock's works as "exciting and unusual." Praised for his naturalness and simplicity, Mondrian was not a simple man. Although seemingly humble in bearing, he knew his own greatness. Called idiosyncratic by reporters who stressed his unusual actions and habits, Mondrian was nonetheless no Bohemian to his friends. Once characterized as "a free spirit, who liked to dance barefoot," he was said to be "morally above most men."

31. *Composition with Red, Yellow and Blue*, 1939-42. Holtzman Collection

He disapproved of self-indulgent artists and obscured his only vice, coffee-drinking, by hiding the pot behind a piece of cardboard. When asked why he never married, Mondrian replied: "I have not come so far. I have been too occupied with my work."

However, women admired him. Dancing was a substitute for women. The artist was described once as "a perfect dancer [who] danced in a way so perfect it was almost too perfect . . . it was alive."

Mondrian's passion for dancing, not just a sublimating factor, was connected intellectually with his appreciation of American jazz music.

He was excited by Boogie-Woogie. Mondrian believed that Boogie-Woogie, said to be the most technical and least melodic form of jazz, bore the same relationship to music as abstract art did to art in general.

As early as 1941, the artist had begun to celebrate jazz on canvas. After his 1942 exhibition at Dudensing's, he continued to compose pictures with colored lines.

The artist may have realized that he had to overcome the spatial effect caused by overlapping colored lines and the optical flicker to be observed at their crossings. He may have begun, at this point, to glue small tapes of different colors onto the crossings and along intervals of the taped, multi-colored lines.

When Mondrian removed the tapes, he painted the small squares they had covered in red, blue, and gray but changed what had been the multi-colored taped lines between the squares to yellow.

32. *Composition with Red, Yellow and Blue*, 1939-42. Tate Gallery, London

In the new painting, which the artist named *Broadway Boogie-Woogie*, he came closer to these goals than ever before.

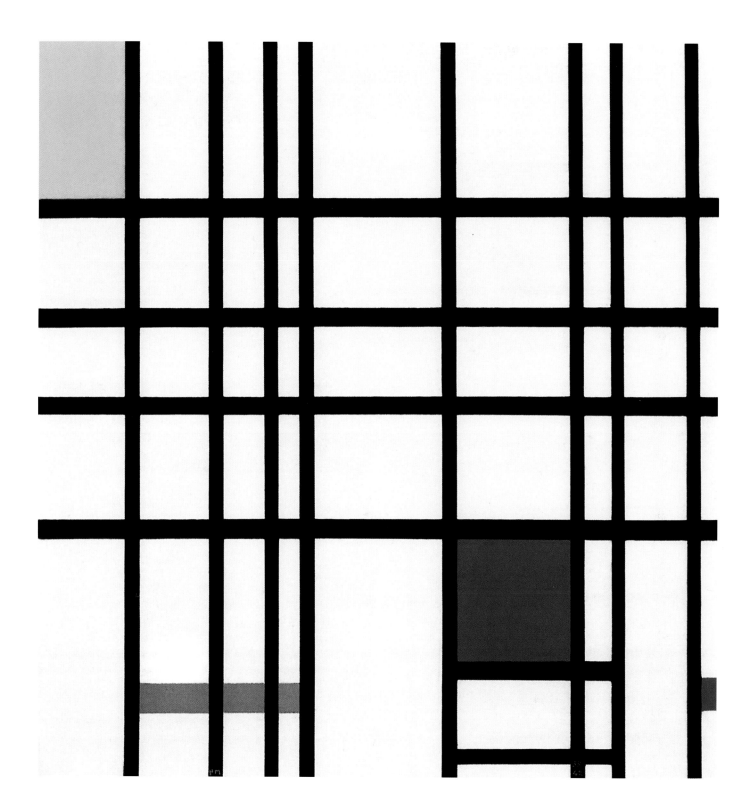

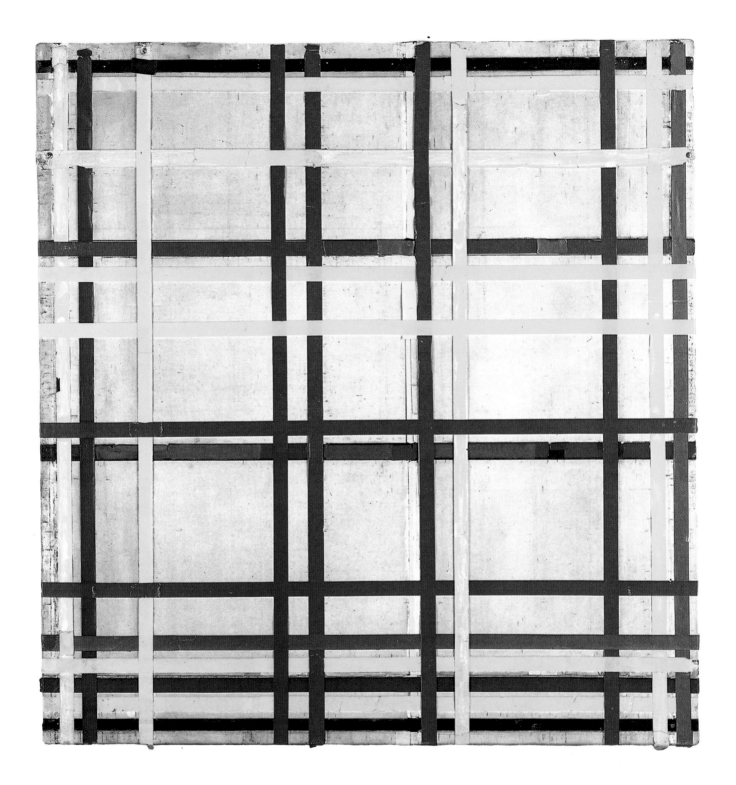

He was creating a composition in the spirit of pure abstraction that he saw as the source of the Boogie-Woogie jazz. *Broadway Boogie-Woogie* was acquired by the Museum of Modern Art in May 1943.

In 1943, Mondrian made a rare confession in an interview with a reporter from the Knickerbocker Weekly: "I am glad that my paintings bring me enough money so I can live alone. I have had a happy life, for my work. It is so difficult to express, to paint what you feel. It is a great struggle. I know that it would really be torture if I shouldn't get it on canvas. I feel never free - there is always this compulsion driving me on. When a picture is finished, I am satisfied for a short while and then the pressure comes again."

Mondrian may have been driven by his efforts, but he was also exhilarated. All of his closest friends attested to the eagerness with which Mondrian undertook his final painting: *Victory Boogie-Woogie*.

33. ***New York City II***
(unfinished), 1942

34. First page of article:
"Twelve Artists in
U.S. Exile," Fortune
Magazine, vol.
XXIV, December
1941, p. 103.
Reproduced courtesy
of Fortune Magazine

The title had been almost inevitable. Not only was "Victory" a word that was heard frequently by now, but it had special poignancy for Mondrian.

Every issue of Knickerbocker Weekly contained stories of hardships, and even atrocities, endured by his Dutch compatriots under the Nazis.

These stories were interspersed with oft-repeated promises of a forthcoming allied victory.

Late in January, 1944, a chronic predisposition to respiratory ailments (in the pre-penicillin era), joined with his neglected cold, fatigue, and unwillingness "to bother anyone," had brought on pneumonia.

Mondrian died, at five o'clock in the morning on Tuesday, February 1, 1944. The lawyer read the simple legacy, endowing "my friend, Holtzman" with the full estate, whereupon Dudensing spoke up and said that the final, unfinished picture belonged to him.

The artist, it seems, had promised the painting to Dudensing because he had not taken a commission on *Broadway Boogie-Woogie*.

Holtzman later explained that he did not question the statement, on the grounds that Dudensing had given Mondrian his only one-man exhibition.

The discussion that ensued centered on what kind of funeral should be held for "an austere man of no religious affiliation."

35. *New York City*, 1942

Finally, the group decided that the ceremony should be a formal one because, as Holty put it: "The master would have loved it so; he respected the conventions and the formality."

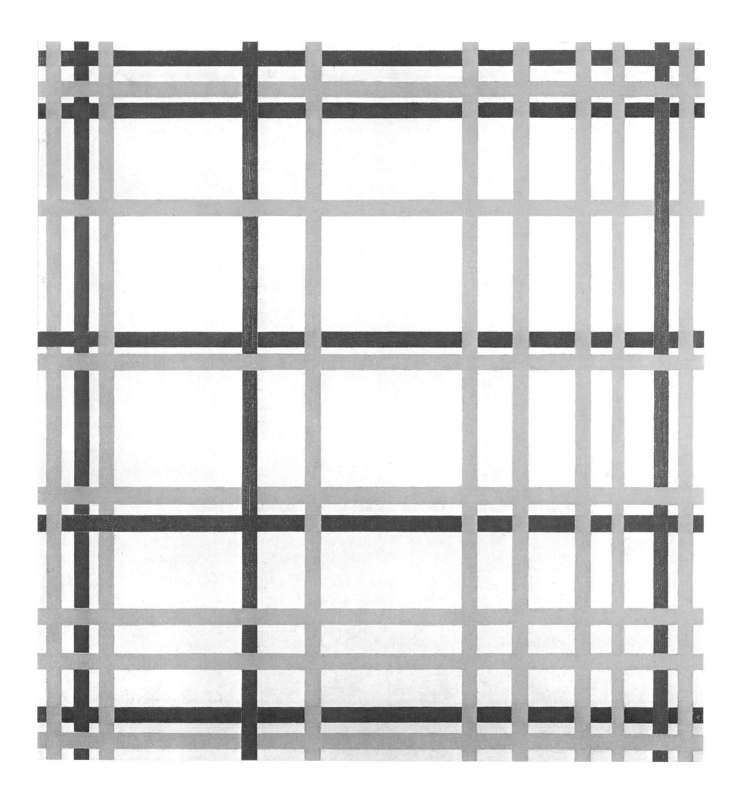

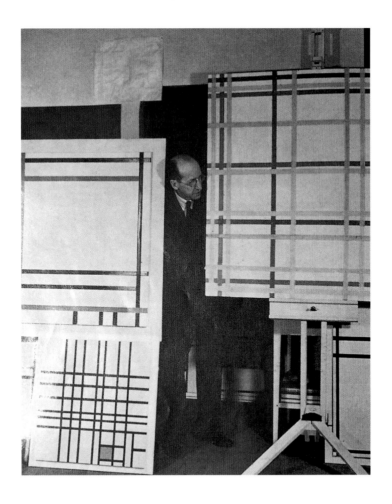

More than two hundred personalities attended Mondrian's funeral including Fernand Léger, Marc Chagall, Max Ernst, Marcel Duchamp and Calder.

In order that other artists could see what Mondrian had done with his second New York studio, Holtzman kept it open for a while after the artist's death. Mondrian had molded, according to his ideals, his studio-apartment, which was always his immediate paradigm of art moving into life.

The room had nothing to interrupt the expanse and bareness of its floor except the easel at the far end. Still on the easel, as Mondrian had left it, was his final, unfinished masterpiece, *Victory Boogie-Woogie*.

36. Photograph of Mondrian in his first New York studio, fall 1941

37. *New York City III* (unfinished), 1942

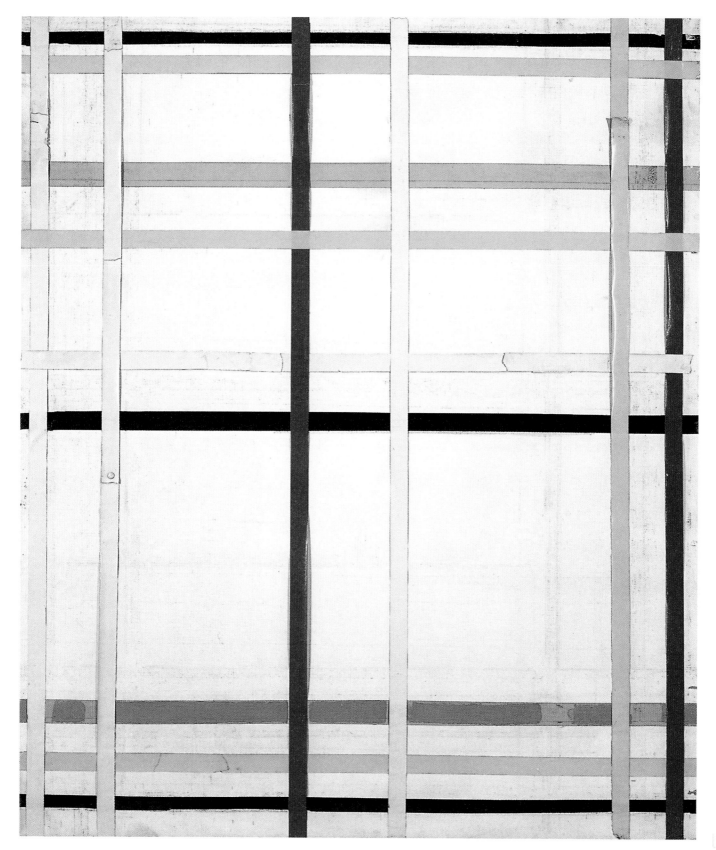

53

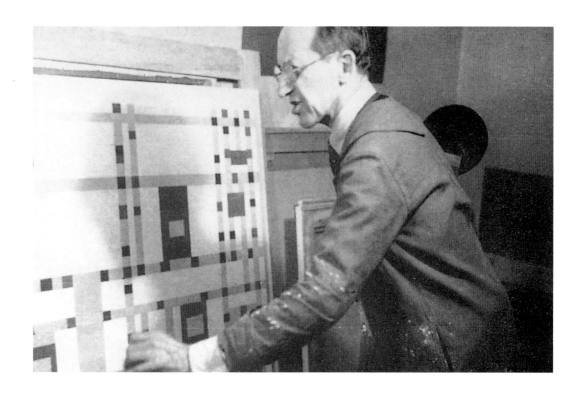

Mondrian's New York Works: Theory and Practice

It was true that Mondrian's theorizing went beyond simply composing pictures. He obviously saw himself as a prophet who would free artists from their past oppressions.

38. Mondrian at work on
Broadway Boogie-Woogie

The best place to propagate his ideas was America, the land of freedom in art as well as life.

39. *Place de la Concorde,* 1938-43. Clark Collection, Dallas

Not that American artists understood him any better than Europeans, but at least they were untrammeled by tradition and had no inhibiting laurels to rest on.

Mondrian wanted to inform, especially in America, and if he failed to proselytize many American artists, at least he gained their confidence.

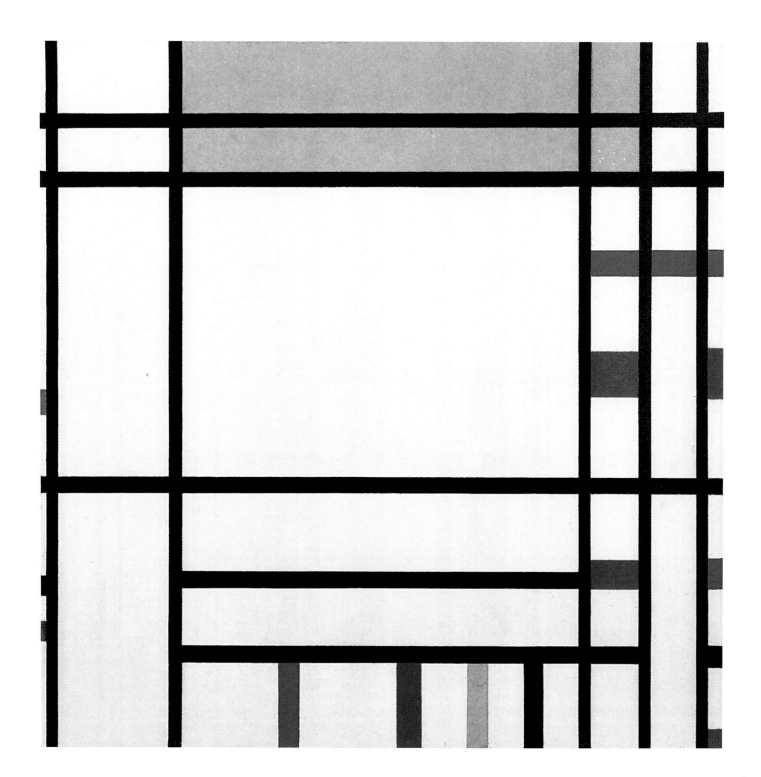

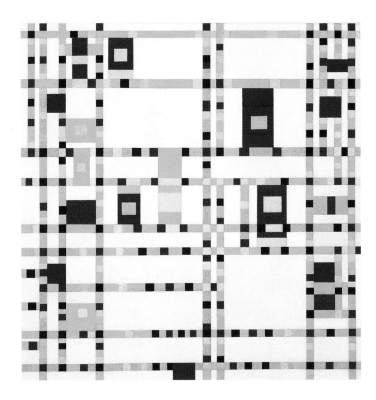

According to Mondrian's logic, not even the American Abstract Artists were as "abstract" as they believed.

Even though these shapes were free from the associations of Synthetic Cubism or Surrealism, they were still too close to nature, being not only impure in color - "not yet primary," in Mondrian's words - but spatially unresolved.

Although the Americans' shapes were abstract, the ground was not; it still gave the effect of space receding from the frame. The shapes and space were thus incoordinate.

40. ***Broadway Boogie-Woogie***, 1942-43.
Museum of Modern Art, New York

In the English publication *Circle* (1937), published the year before he moved from Paris to London, he wrote of "the direct creation of universal beauty."

Probably motivated by the general lack of understanding he encountered in America, as well as by a genuine desire to elucidate his ideas, Mondrian made his most thorough attempt to explain the application of his theory in "A New Realism," written for his Nierendorf Gallery lecture of January, 1942.

He again negated the idea that art should be simply the expression of space, since space does not represent life but only contains it.

In art, therefore, space must be controlled plastically by reduction of three-dimensional space to the conformations of a two-dimensional canvas. Rectangles represented in his system "forms" and "colors," both of which he had attenuated to their "purest" or least equivocal states.

Nevertheless, Mondrian could not isolate them nor leave them unbounded by the lines, because the rectangles would then appear as entities.

By maintaining their vertical-horizontal placement and binding them with the space-limiting lines, Mondrian brought rectangles into equivalence with non-color areas or "spaces," which had also been formed into rectangles by the crossings of the lines.

All contiguous entities and areas were then in "rapport" (Vantongerloo's term) and thereby demonstrated "the unity of form and space." Naum Gabo referred to Mondrian's ideas in a 1966 interview: "He was against space. His ideas were very clear. He thought a painting must be flat, and that colour should not show any indication of space."

This was a main principle of neo-plasticism. Obviously, the artist believed that only by careful execution could he make his surfaces appear to be flat. That is, only by repeated applications of paint - whether in color, or "non-color" - could he create surfaces that were both attractive and objective.

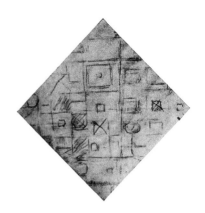

41. Mondrian's sketch for *Victory Boogie-Woogie*, c.1943. Holtzman Collection

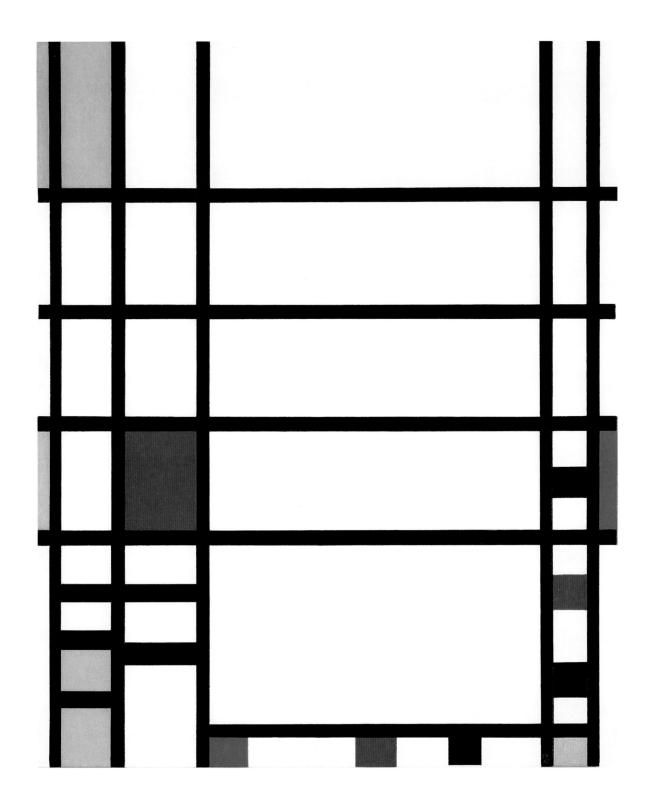

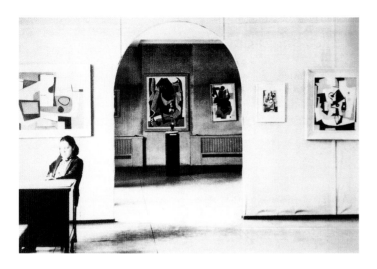

Holty thought Mondrian's care in execution made the difference between his paintings and those of his followers. Even if he did not strive for an obvious painterliness, the artist achieved a very personal and traditional patina.

He not only left the whites thick but painted the whites again and again to give them a special intensity as well as to mitigate the strength of the blacks that otherwise would appear to come forward, like a grid.

Despite the fact that in later years critics frequently referred to a "grid" when describing the artist's work, he never mentioned the term and would, in fact, have found it untenable. The blacks had to be kept lower.

When the artist had finally finished the painting process, his white spaces did not recede but seemed to lie on the surface, gleaming with light.

As the "tensions" pulled between planes of different sizes, intensities, and thicknesses, the surfaces also seemed to quiver, even though they resolved rhythmically into ultimate "equilibrium."

42. *Trafalgar Square,* 1939-43. Museum of Modern Art, New York

43. View in first American Abstract Artists Exhibition, Squibb Galleries, 1937

Not until he began to think pragmatically, or visually, could the artist see that the planes in color did not simply join when they met, as black ones did, but appeared to move over and under one another.

He had again produced the appearance of space - that is, a disunity of ground and elements; there was no longer a fine equivalence of structure and means with space.

One can say that in *Broadway Boogie-Woogie* his immediate solution was to pin the lines to the ground by painting squares of contrasting colors at their crossings.

So that the crossing squares would not merely pin down lines but would still serve their primary function as means, the artist then painted other squares in alternating sequences of color along the segments of lines between the crossings.

Holty said that the artist was still dissatisfied when *Broadway Boogie-Woogie* was finished. After he saw the painting hanging in the Museum of Modern Art, he felt that its effect was weakened by the preponderance of yellow.

The colors had looked clearer and more distinct in the small space of Mondrian's studio than in the larger gallery at the museum. Shortly before he died, Mondrian spoke of the "great struggle" to realize his aims that was "always going on."

Even if his fate was like that of other geniuses who died long before their work was fully understood, the artist's ideas, even in his last momentous quest, were to be acknowledged in the United States as nowhere else. It was fitting that he should be laid to rest in the country of his choice, because even if Mondrian did not finish his work there, he brought it to a resounding climax.

44. *Composition I with Blue and Yellow*, 1925. Kunsthaus, Zurich

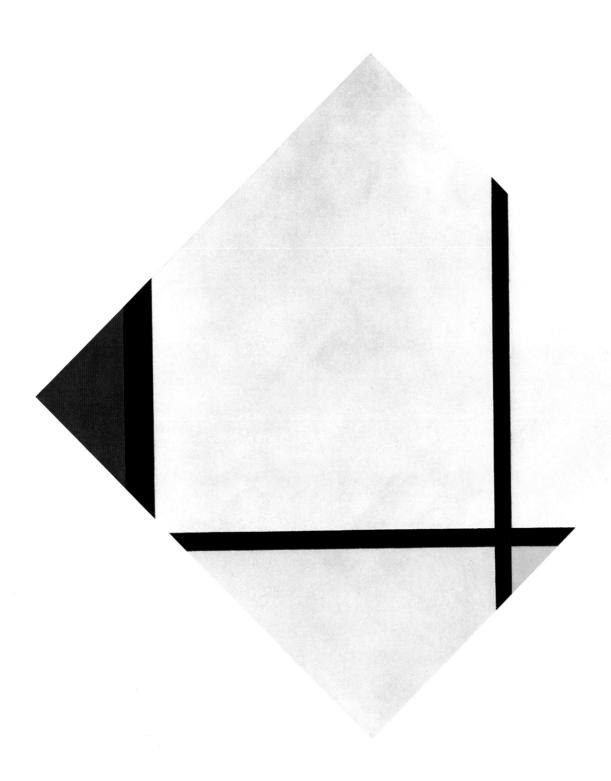

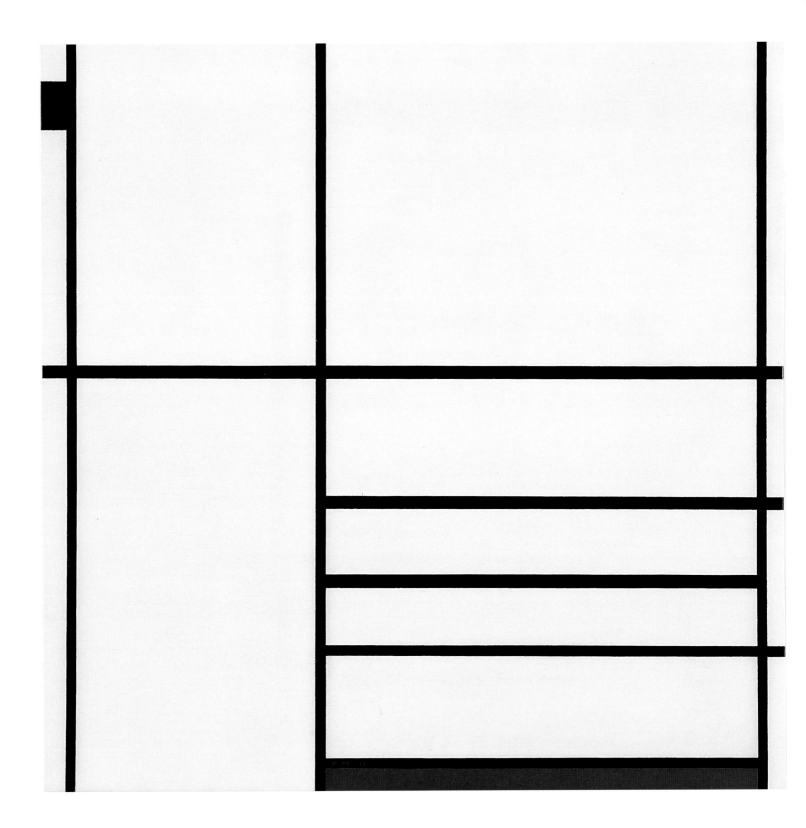

The Immediate Followers

Like Mondrian, his followers believed that investigation of a single line of reasoning was as vital in art as any other field of endeavor, and that it should be judged within parameters set by the investigator.

Despite his belief in the commonality of the "expressive means," Mondrian's paintings were completely idiosyncratic and those of the followers were clearly distinguishable from his.

It was both to his credit and theirs that they did not copy his usage but chose to work "within the logic of the style."

In fact, Mondrian's principle of impersonality with its implication of freedom from discipleship was what originally attracted Harry Holtzman, born in 1912 in New York.

When Holtzman first brought together the abstract artists who formed AAA, he had hoped they would establish Mondrian's "essential trend," as he called it, but this ambition was thwarted somewhat.

The other artists had less ambition to discuss the fine points of theory than to exhibit. Holtzman's understanding of Mondrian's example and the elder artist's principles was reflected in his statements written for the publications of AAA and in his paintings that were shown in the group's exhibitions.

Since Holtzman was the first AAA artist to follow Mondrian's theory, he was the one who was accused most severely of imitation.
That fact, combined with jealousies that developed over what some believed to be his undue influence on the older man, caused Holtzman to be reluctant about showing his paintings.

45. *Composition in White, Black and Red*, 1936. Museum of Modern Art, New York

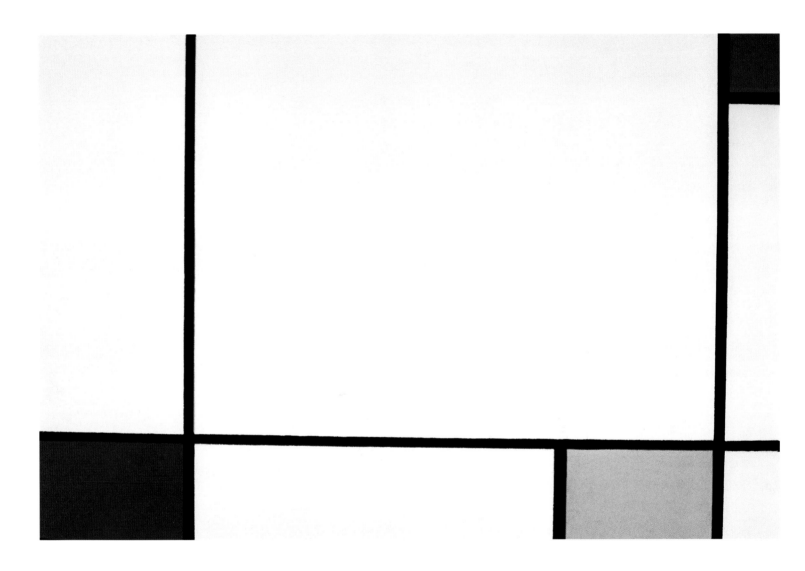

Privately he continued to work, but publicly he devoted himself to exhibiting his mentor's paintings or translating his writings.

Another important follower of Mondrian was Ilya Bolotowsky, born in St. Petersburg, Russia, in 1907. Bolotowsky was immediately attracted to Mondrian's paintings on first seeing them at the Gallatin Museum.

His *Arctic Diamond*, 1948, showed the early nature of that influence, although he used diagonals and a greater number and variety of planes and colors in the lozenge form than the older artist did.

Bolotowsky's increased use of color came from a need within himself "to do something more fresh and personal." In paintings of the 1960s, Bolotowsky illustrated his more personal version of Neoplasticism by aligning colored shapes that appeared to alter their sizes and color relationships. It was their implication of a new reality distinctly different from nature that led him to the columnar paintings.

The idea had evolved as he continued the surface planes around the edges of the easel paintings. He felt that rotating a column on a stand or having the viewer walk around it created a "sequence of design in motion."

The artist's personal variation on Neoplasticism was in color and canvas shape. He kept the vertical-horizontal interior elements while departing from the primaries and the rectangular canvas.

Thus the artist's paintings actually defined Neoplasticism by their deviation from it, and he created a style as distinctive as that of any other Mondrian disciple.

Burgoyne Diller, born in New York City in 1906, came to think of himself, during his last years, more as van Doesburg's artistic descendent than Mondrian's.

46. *Composition with Red, Yellow and Blue*. Stedelijk Museum, Amsterdam

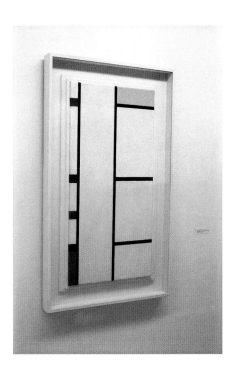

It is indisputable, however, that Diller was introduced to *De Stijl* by seeing Mondrian's work and that he always retained certain aspects of that artist's influence.

47. ***Composition***, 1936-43. Moderna Museet, Stockholm (photographed at Guggenheim Museum, 1971)

The artist's work showed an abrupt change to Neoplasticism in 1934, suggesting that he saw Mondrian's art at about that time.

Geometric Composition, 1934, with its reduced color planes delineated with cruciformed and doubled blacks, was a watered-down version of what the older artist was doing earlier in the 1930s.

48. ***Composition with Two Lines***, 1931. Stedelijk Museum, Amsterdam

In the late 1930s and early 1940s, the artist made wood relief and freestanding constructions in a version of the Neoplastic style. In his works, Diller created a spatial effect never found in Mondrian's work. Diller also treated these themes in drawings.

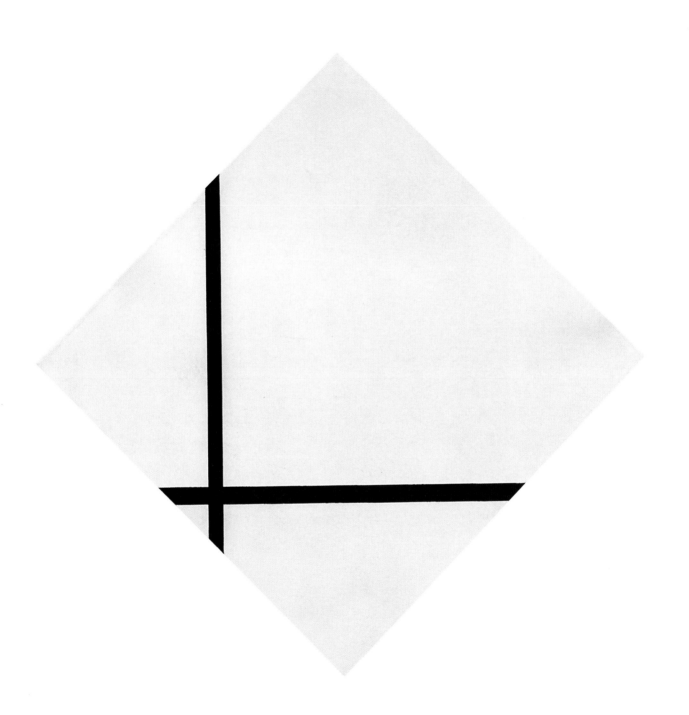

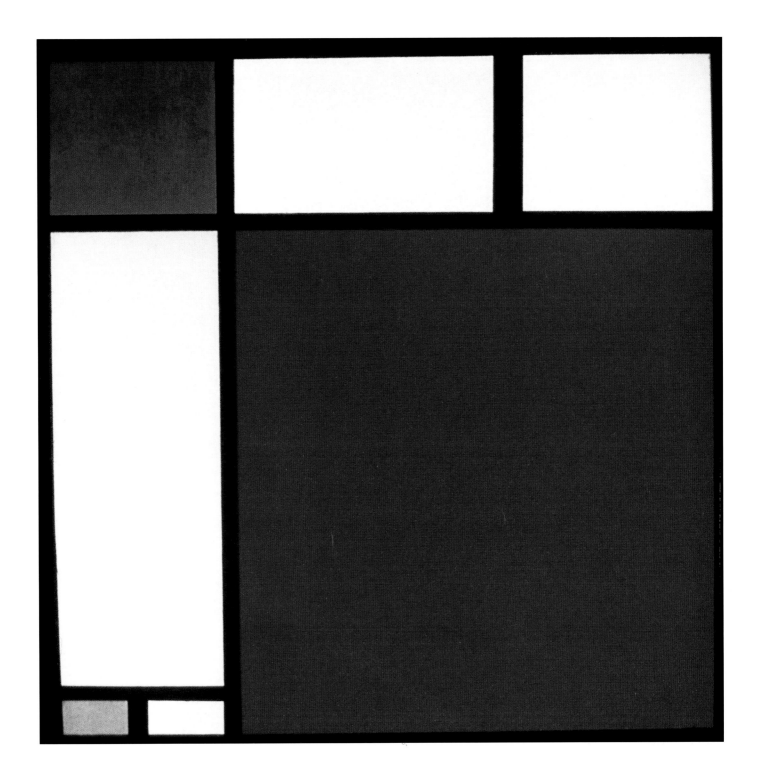

Two of the drawings dated in the 1940s showed his respective influence from Mondrian's diamond paintings of the 1930s and of *New York City*, 1942.

Despite his protestations, the artist was in some respects closer to Mondrian than were the other Neoplasticists. Like Mondrian, he used primary colors and non-colors exclusively; the younger artist also experimented to get the right mixtures.

In a review discussing the artists in an exhibition of Mondrian's American Circle held in Chicago, Jack Burnham said of Diller's work that he "quite possibly had the best grasp of Mondrian's evolutionary intentions."

It would be natural to expect Fritz Glarner, born in 1899 in Zurich, whose training and artistic development were entirely in Europe, to seem the most European of Mondrian's American followers.

Before knowing Mondrian, however, he had reached a stage of problem-solving that put him on the verge of the Neoplastic solution.

The artists met in around 1927, in Paris. At that time, Glarner was impressed neither with the elder artist nor with his work.

However, when meeting Mondrian once again in New York, Glarner was affected by his continual search during the *Boogie-Woogie* period for a way to integrate form and color completely with the plane.

Composition, 1942, illustrated the artist's realization that in order to establish the painting's dimensions objectively, he had to anchor its composition securely to the edges of the canvas, "as the rectangle was the only fixed factor to which all the parts of the painting were constantly related." With its white ground, black lines of varying thicknesses, and use of primary red and yellow, this painting already showed Mondrian's influence.

49. *Composition with Red, Yellow and Blue*, 1930. Armand Bartos Collection

The artist maintained the same approach to another canvas shape, the tondo, that he employed out of respect for the Italian Renaissance tradition. He did not choose a round format for variety's sake but to demonstrate further his theory of Neoplasticism.

Glarner thought, in other words, that he could determine the space of a circular canvas even more exactly than a rectangular one because the component rectangles could neither be extended implicitly beyond its surface as with a rectangular canvas, nor be so easily interchanged.

The artist composed many subtle variations on this format, such as *Relational Painting, Tondo No. 3*, 1945. Glarner shared with Mondrian a penchant for painterly technique that probably came from the two artists' European backgrounds. Both produced on their canvases a fabric of sensitively-brushed strokes.

Like his "master," Glarner saw his form of Neoplastic Relational Painting as part of "a step-by-step development toward the essential integration of all plastic art."

Charmion von Wiegand was born in Chicago around 1900, but did not begin painting until 1926. As a result of her visit to Mondrian's studio, the young artist became fascinated with Neoplasticism and began to study it on her own; later, she helped Mondrian with his writing and frequently watched him paint.

The artist was led into abstraction after Mondrian's death. She claimed that Mondrian was her most important teacher; he "transformed my life in art and gave me discipline and the goal which leads to freedom," she said.

50. *Composition with Blue*, 1937. Gemeentemuseum, The Hague

Yet she did not work under his influence until over a year after he died. She found herself fascinated by the color notes and oriental canons - Egyptian, Chinese, Indian, and Tibetan.

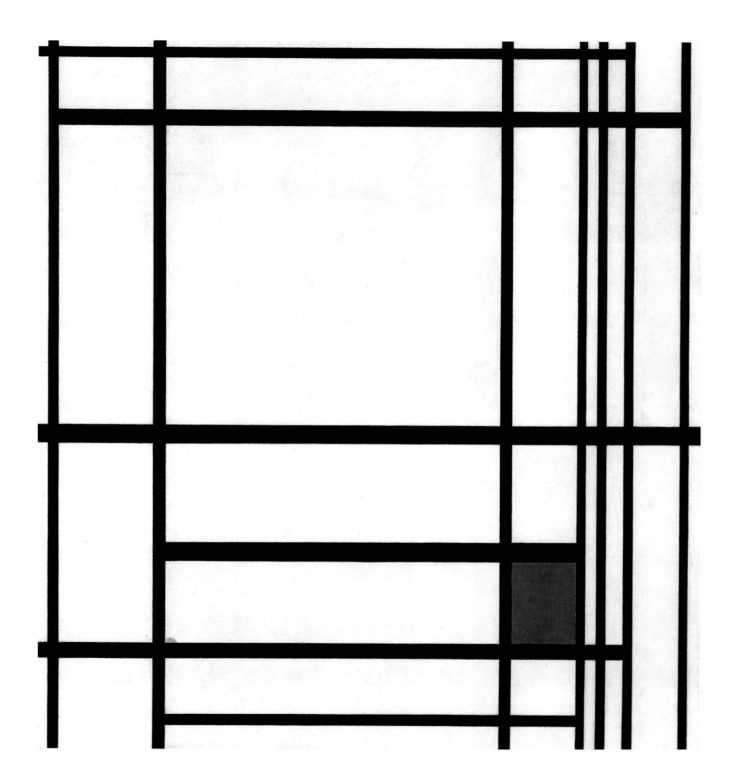

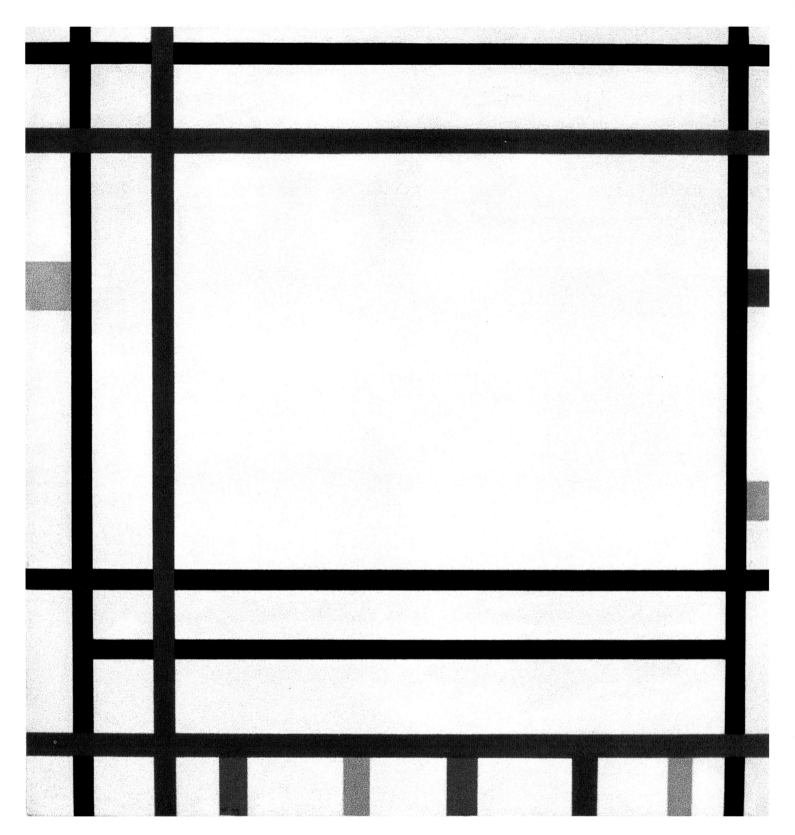

In *Ka Door*, 1950, primary colors dominated her palette, and the vertical-horizontal framework containing linear planes broken by small squares strung along their lengths was strongly reminiscent of Mondrian's *Victory Boogie-Woogie*.

Gradually, von Wiegand's interests turned more and more to the East, her imagery almost exclusively from Tantric imagery, mostly Buddhist, which is already geometric.

Thus it seemed perfectly natural to the artist to move via Mondrian's principles to paintings that were inspired by oriental principles.

Her later works diverged far from Mondrian's course in that she introduced diagonals and curves and altered colors to include a variety of tints and mixtures.

And when von Wiegand added explicit content, equating colors and geometric shapes with the arcana of certain oriental systems, her work became, in fact, antithetical to her mentor's. Nevertheless, she was linked to the man she called her master.

In the 1940s and 1950s, many artists were affected by the theories of Mondrian, as was Leon Polk Smith who expresses the admiration he felt for the older artist in his paintings, such as *Homage to 'Victory Boogie Woogie' No.1*, 1946-1947. Among the multitude of artists influenced by Mondrian, there were those who rejected him. Nevertheless, these artists were equally marked by his impact as those who did not deviate a iota from his ideas. This was the case of Charles Biederman, Jackson Pollock, Barnett Newman, Marc Rothko, and Ad Reinhardt.

51. *New York*, 1941-42.
 Harold Diamond
 Collection

Despite everything, Mondrian's most important legacy for artists then and for those of the future is freedom.

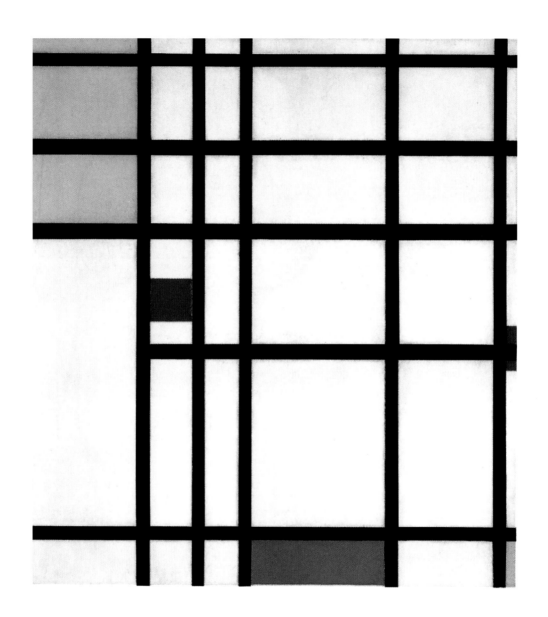

Biography

1872:
Pieter Cornelis Mondrian Jr is born on March 7th in Amersfoort.

1886:
The young Pieter finishes his primary studies and begins teaching himself to paint under the direction of his father and his uncle, the painter Frits Mondriaan.

1889:
He successfully passes the exam to become a primary school drawing teacher.

1892:
He passes the exam to become a secondary school drawing teacher and registers as a student at The Academy of Fine Arts in Amsterdam.

1897:
He has his first exposition at *Arti et amicitiae*.

1901:
He competes in the first level for the Prize of Rome for painting.

1904:
Lives and works in absolute retreat in Uden.

1908:
First voyage to Domburg. Thereafter he will take a trip to Domburg each year.

52. ***Composition with Red, Yellow, and Blue***, 1936-43. Moderna Museet, Stockholm

1909:

First important exposition with Cornelis Spoor and Jan Sluyters at the Stedelijk Museum of Amsterdam. It is the first time that his luminous works are shown. In May, he joins the Theosophical Society.

1910:

Becomes a member of the *Modern Kunstkring* with C. Kickert ("Modern Art Circle").

1911:

Registers at the Independent Salon in Paris and prepares to leave for Paris after having been greatly impressed by the works of Braque and Picasso.

1912:

Mondrian settles down in Paris.

1914:

Makes a visit to his father in Arnhem during the summer. The declaration of war hinders him from returning to Paris.

1916:

Mondrian starts to write down his theories on art in essays and dialogues which will eventually be published in a review that he will found with Theo van Doesburg.

1917:

Publication of the first issue of *De Stijl* in which Mondrian gives the first of his essays on *De nieuwe beelding in de schilderkunst* (The New Plastic in Painting). He does one of his first entirely abstract compositions.

53. *Composition*, 1917.
Kröller-Müller
Museum, Otterlo

1918:

Mondrian contributes to the first manifesto of *De Stijl*.

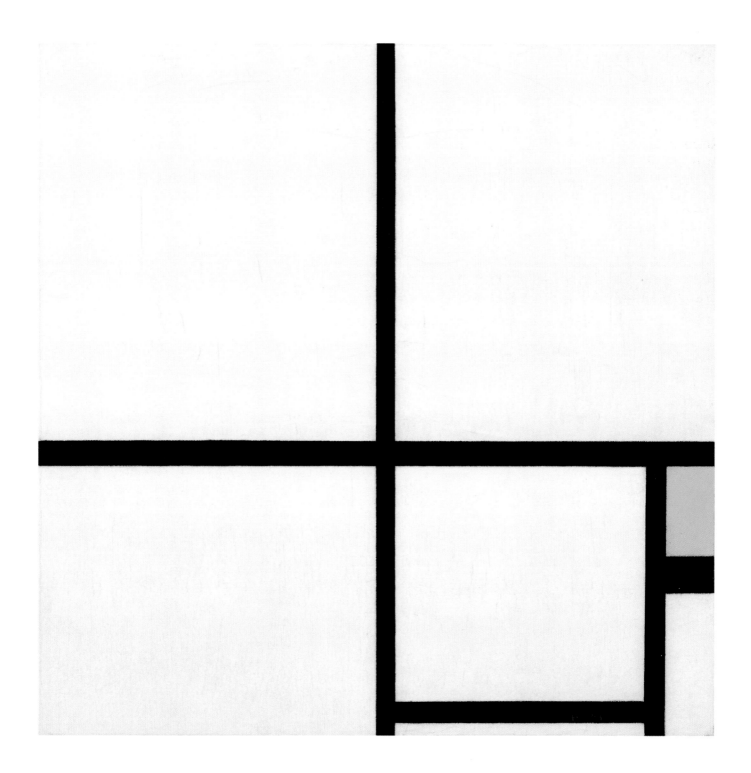

1921:

Mondrian restricts the colors in his compositions to the primary colors: red, yellow and blue.

1922:

Retrospective at the Stedelijk Museum of Amsterdam organized for his fiftieth birthday.

1925:

Mondrian leaves *De Stijl*.

1930:

He exhibits with the group "Circle and Square", founded by J. Torres-Garcia and M. Seuphor.

1931:

He enters the group "Abstraction-Creation," founded by G. Vantongerloo and A. Herbin.

1937:

Publication of his essay *Plastic Art and Pure Plastic Art*.

1938:

Leaves Paris to live in London.

1940:

Leaves London to take refuge in New York where he is welcomed by Harry Holtzman, J.J. Sweeney, F. Glarner, Peggy Guggenheim and others.

1942-1943:

Expositions at the Valentine Dudensing Gallery.

1944:

Dies of pneumonia on February 1st in New York.

54. *Composition with Yellow*, 1933. Kunstsammlung, Nordrhein-Westfalen, Düsseldorf

LIST OF ILLUSTRATIONS